First paint two big blobs for the eyes

With your thick brush paint a big pink blob for the mouth. Wait for it to dry!

Now, using your thin brush paint four smaller dots inside the pink blob.

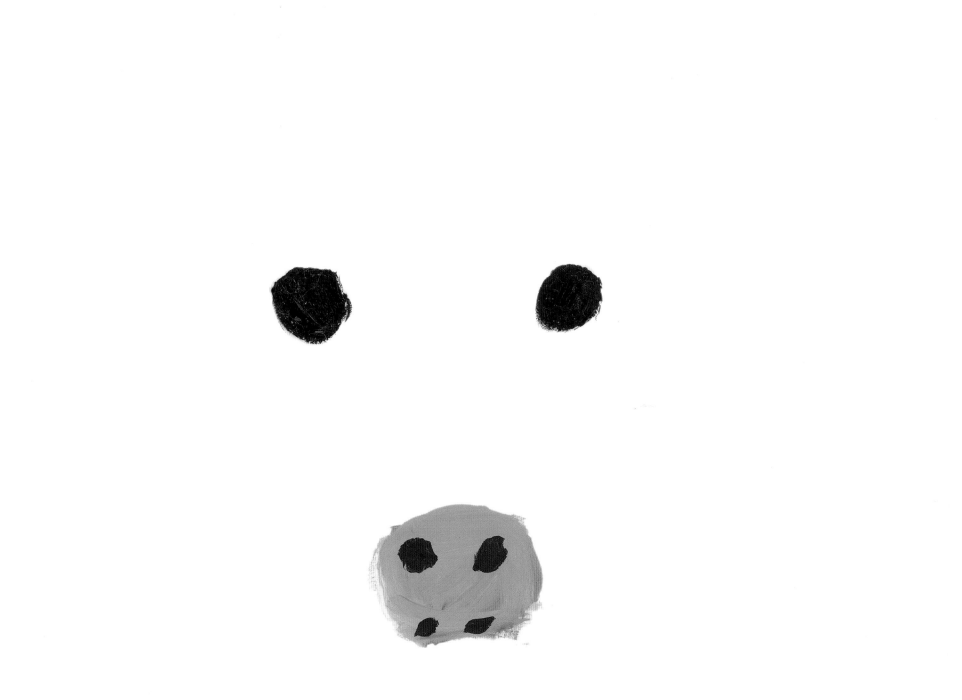

Using your dark brown paint, draw circles around her eyes and give her a mop of wavy brown hair.

Paint her forehead white or cream.

Don't worry if it gets messy, paint is always messy!

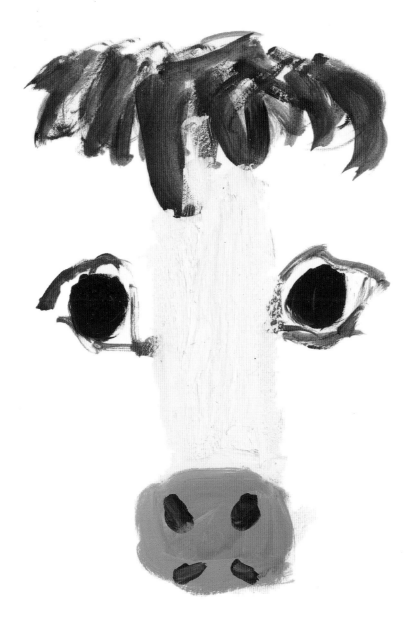

Use your light brown to paint one side of your cow's face.

Remember to add in a big fluffy ear on that side too!

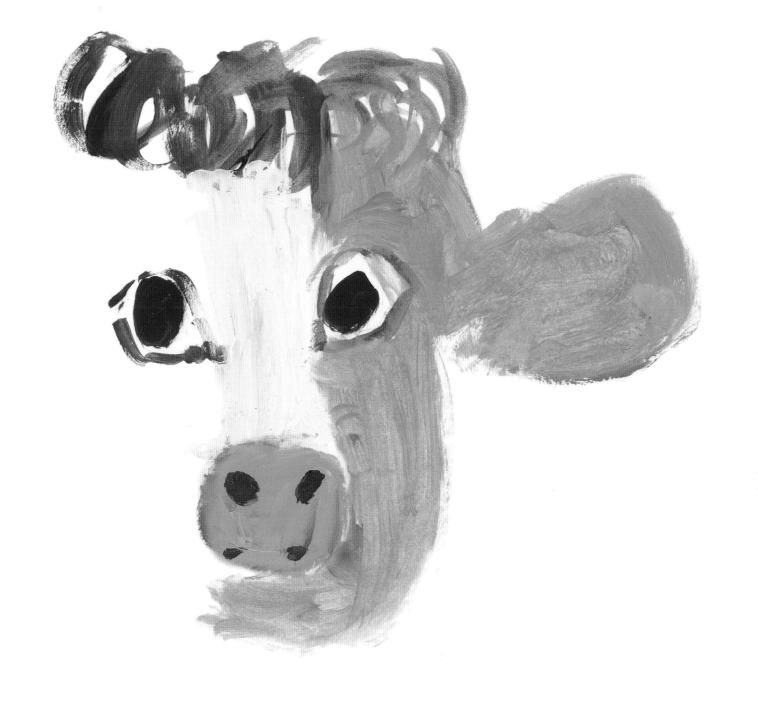

Before you paint in the other side of her face,
mix in a bit of the dark brown paint.

This way, each side of the face will be different!

Don't forget to add in the other big fluffy ear!

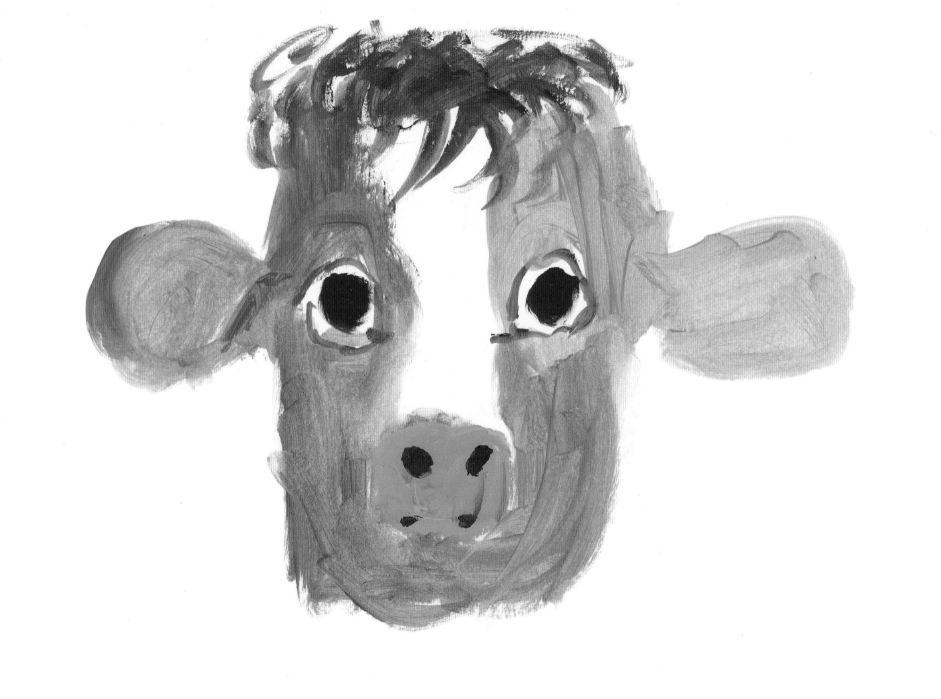

Keep using that dark brown to add some blobs to the ears and then make a body!

Add some darker strokes to the hair and under the chin.

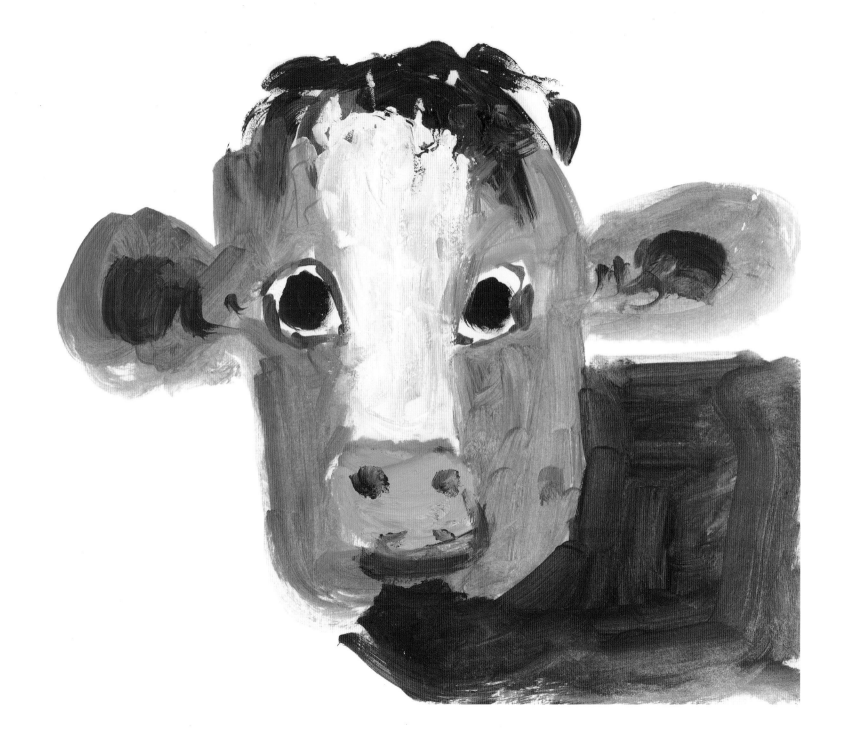

Red is my favourite colour, which is why I have used it for this background!

What colour will you choose for your background?

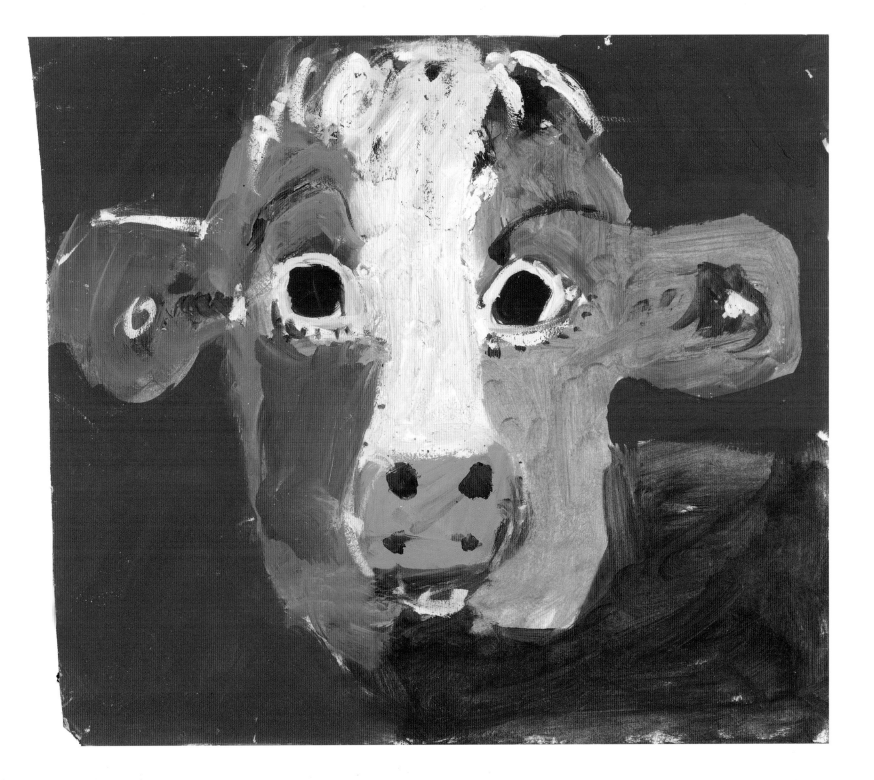

Why not put a flower in your cow's mouth? You can mix green with white for the stem, and add yellow for the centre of the flower.

Give her some eyelashes too... I have used dark brown and added more white around the eyes.

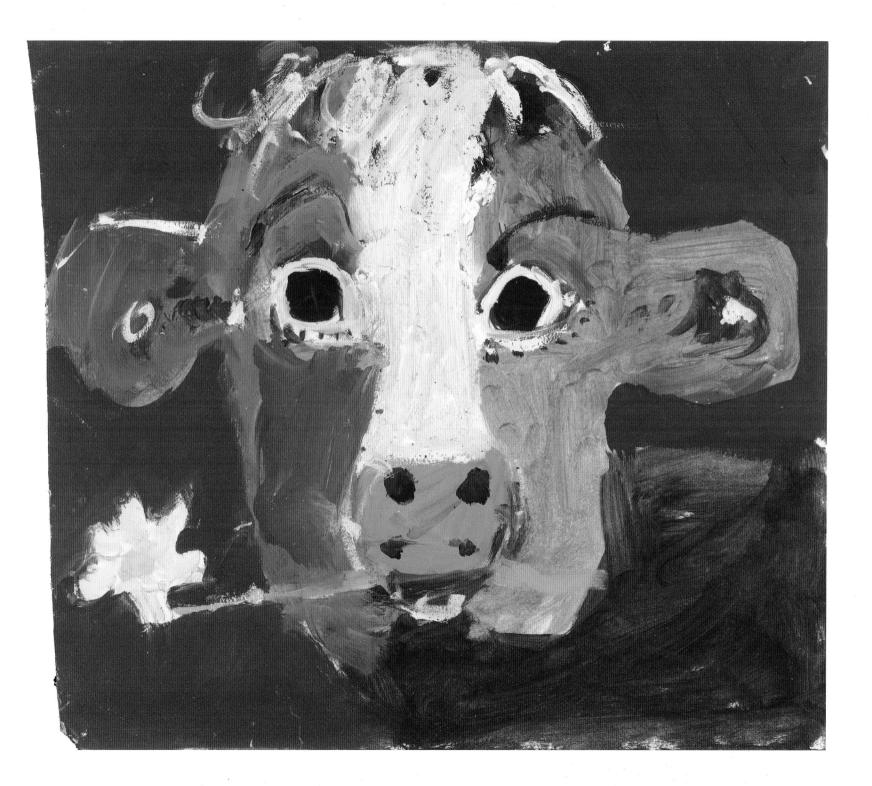

Add white dots to the eyes and more wisps of white paint to make curls on top of her head.

Last of all, you can outline her face.

That's it, you've painted a Cow...

(now give her a big kiss!)

Published by: Associated Editions
33 Melrose Avenue, Dublin 3
ISBN 978-1-906429-14-0
www.associatededitions.ie
© Images: Deborah Donnelly
© Catalogue text: Deborah Donnelly,
Anne Brady & Éamonn Hurley 2010

ASSOCIATED EDITIONS
www.associatededitions.ie